EXTREME
DOT TO DOT
Spectacular Places

If you think dot-to-dot drawing is kids' stuff, then think again. To enter the world of extreme dot-to-dot you'll need concentration, patience, a sharp pencil – and the ability to count to well over a thousand!

The 42 incredible dot-to-dot puzzles in this book are a challenge for even serious solvers. Each one contains a minimum of 1,200 numbered dots. Join them – in the right order – and an amazing image will emerge before your eyes.

This collection of puzzle pictures takes you on a multi-stop tour of the globe, with each page featuring a wonder of the world, an architectural marvel, or a well-known attraction. All will be revealed as famous cityscapes, iconic buildings and inspiring landscapes gradually take shape.

Some will present themselves to you early on, while others will hold on to their secret for a little longer. Guessing what you're drawing is very much part of the enjoyment – and if you simply can't wait to know, you can always check for the solution at the back of the book!

Compelling and engrossing, extreme dot-to-dot provides an alternative to the ubiquitous electronic screen. It's a welcome distraction from the cares of modern life and a great way to while away the hours. When you're finished, you'll have a pleasing sense of achievement plus a fabulous work of art that will make you proud.

In these pages there are more than 50,000 dots to link, so what are you waiting for? Grab a pencil, focus your mind, start drawing and discover where the lines take you!

Once called "the bridge that couldn't be built", this magnificent structure is 1.7 miles-long and contains about 88,000 tons of steel. Completed in 1937 it has been crossed by more than two billion vehicles.

Just where is this wonder of the modern world?

This famous structure took 14 years and cost $15 million to complete back in 1883. At the time it linked two separate cities, but now it's part of the same mega-metropolis.

Can you solve this architectural riddle?

This massive amphitheatre that once seated more than 50,000 spectators stands proudly in the midst of a modern city. It previously hosted gladiatorial combats, wild animal fights and mock naval engagements, but now just welcomes tourists.

Can you work out what it is?

This long creature with the famously inscrutable
face of a human being and the body of a lion stands watch
over some of the greatest man-made marvels of the world.

What is it and what exactly is it guarding?

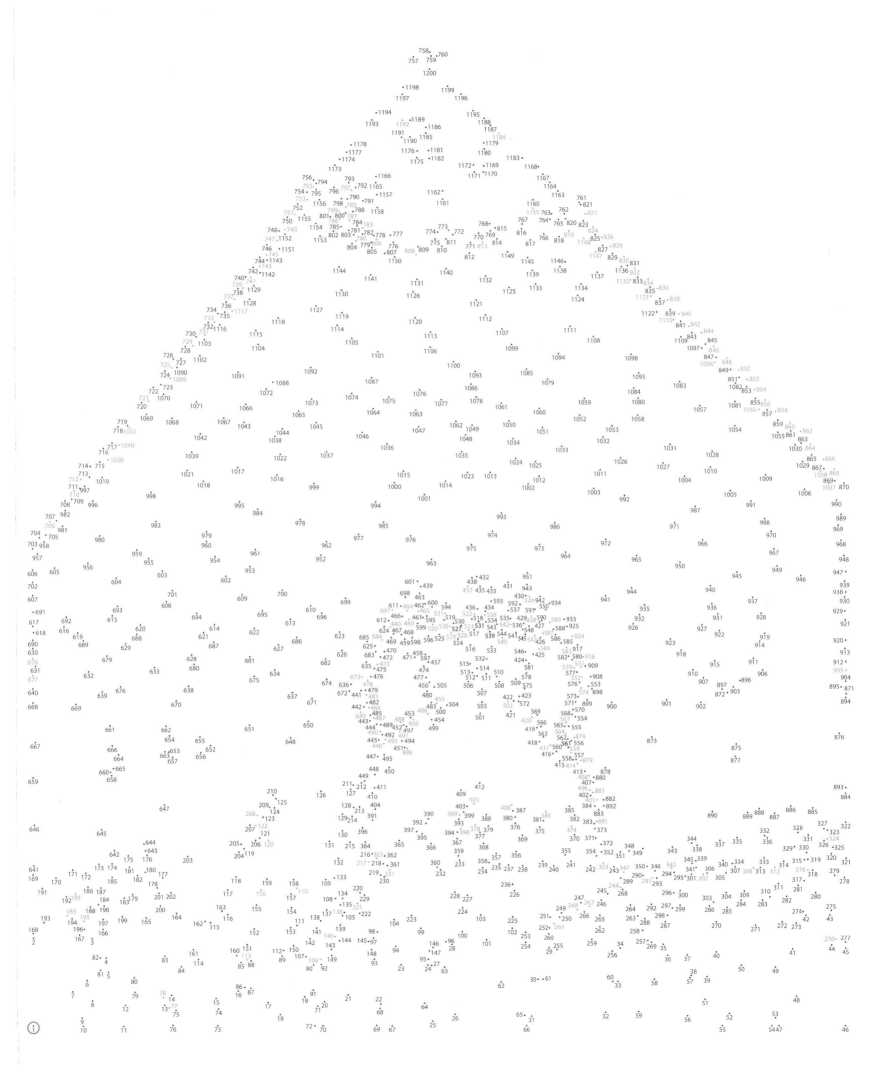

For centuries this Italian building has attracted tourists who marvel at its construction. It is not the tallest, oldest, or most beautiful of buildings, but it is unique and amazing.

Let the dots reveal the nature of this famous site.

It took more than 1,000 elephants to transport the materials and 22,000 workers to build this immense white marble memorial of delicate minarets, gracefully curved archways and ice-cream scoop domes.

So what and where is this wonder of the modern world?

This series of defensive fortifications spanning
13,000 miles was built over many centuries, and
it's a myth that it can be seen from space.

Can you reveal what it is on the page?

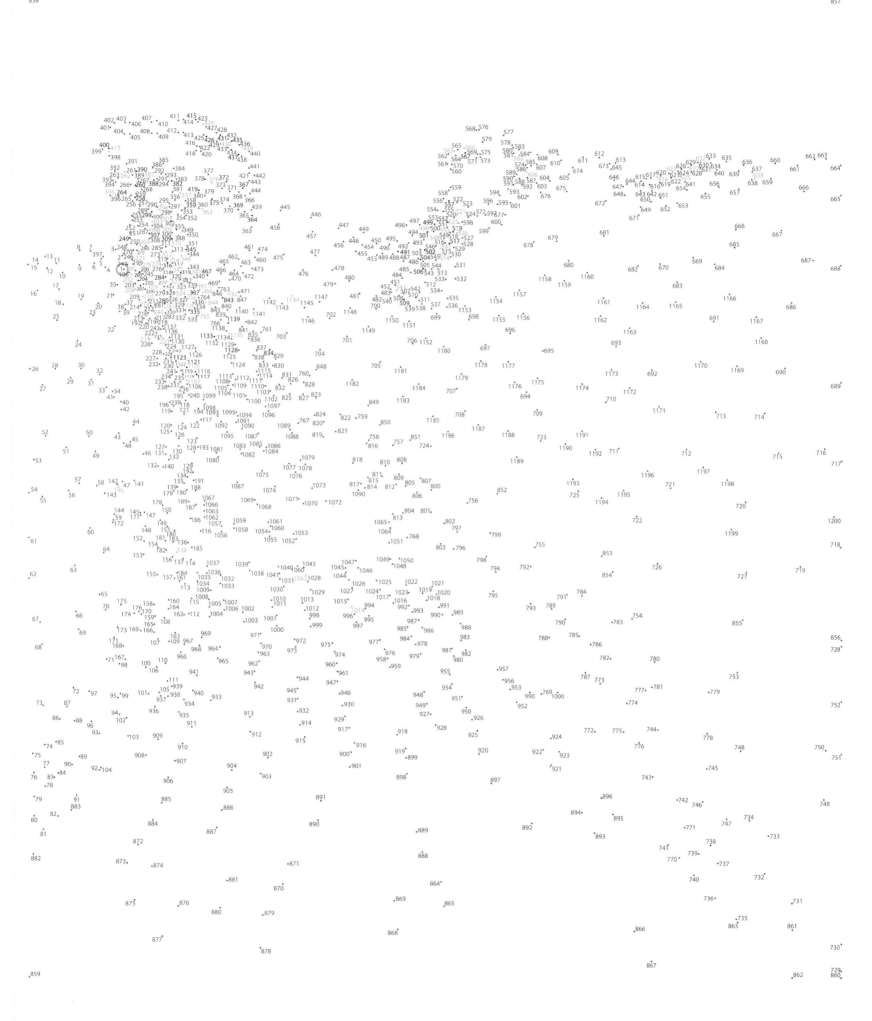

This is the world's tallest steel arch bridge, which
spans the beautiful blue waters of the city harbour.

So where is this famous structure
that the locals call "The Coathanger"?

Once considered the most prestigious and grandest building
of its type in Europe, it was famous for its library, and for
hundreds of years contained the largest church in Christendom.

Can you make the dots reveal what and where it is?

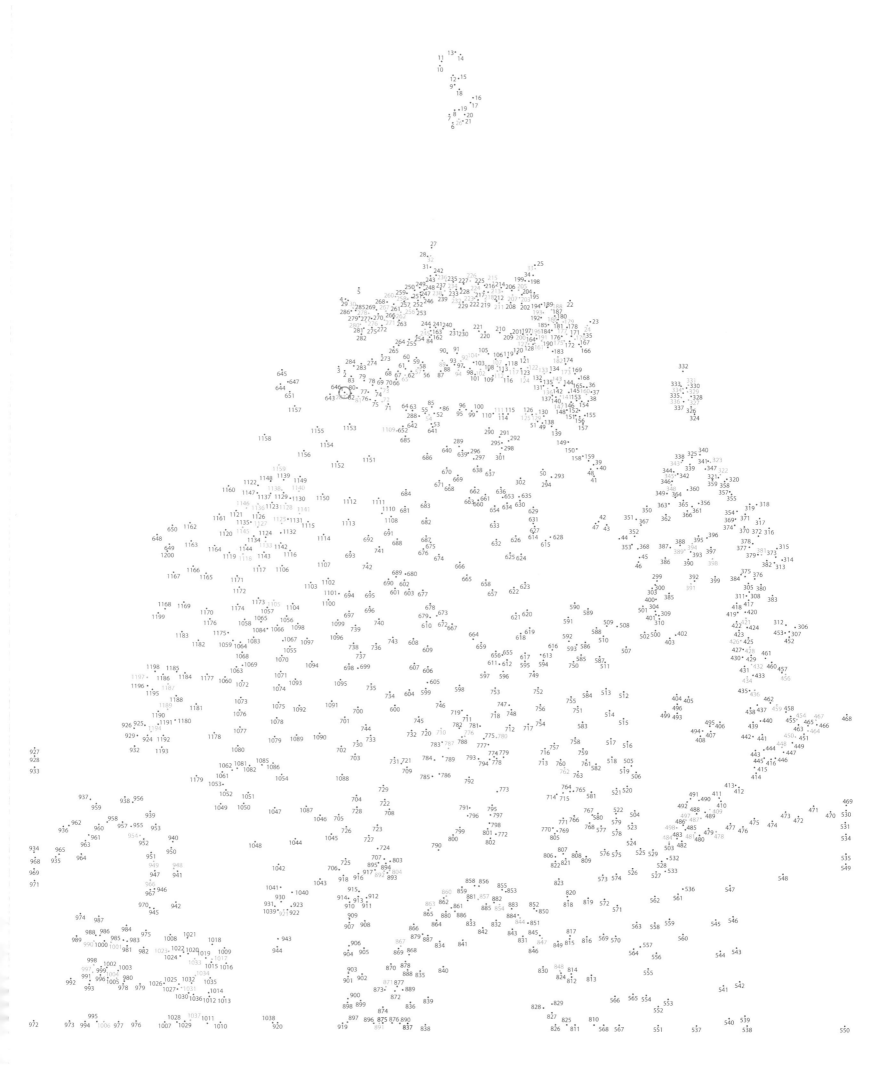

It's more than 270 miles long, up to 18 miles wide and up to 1 mile-deep. One of the USA's great tourist spots, it attracts nearly five million visitors each year.

What is it and in which state does it lie?

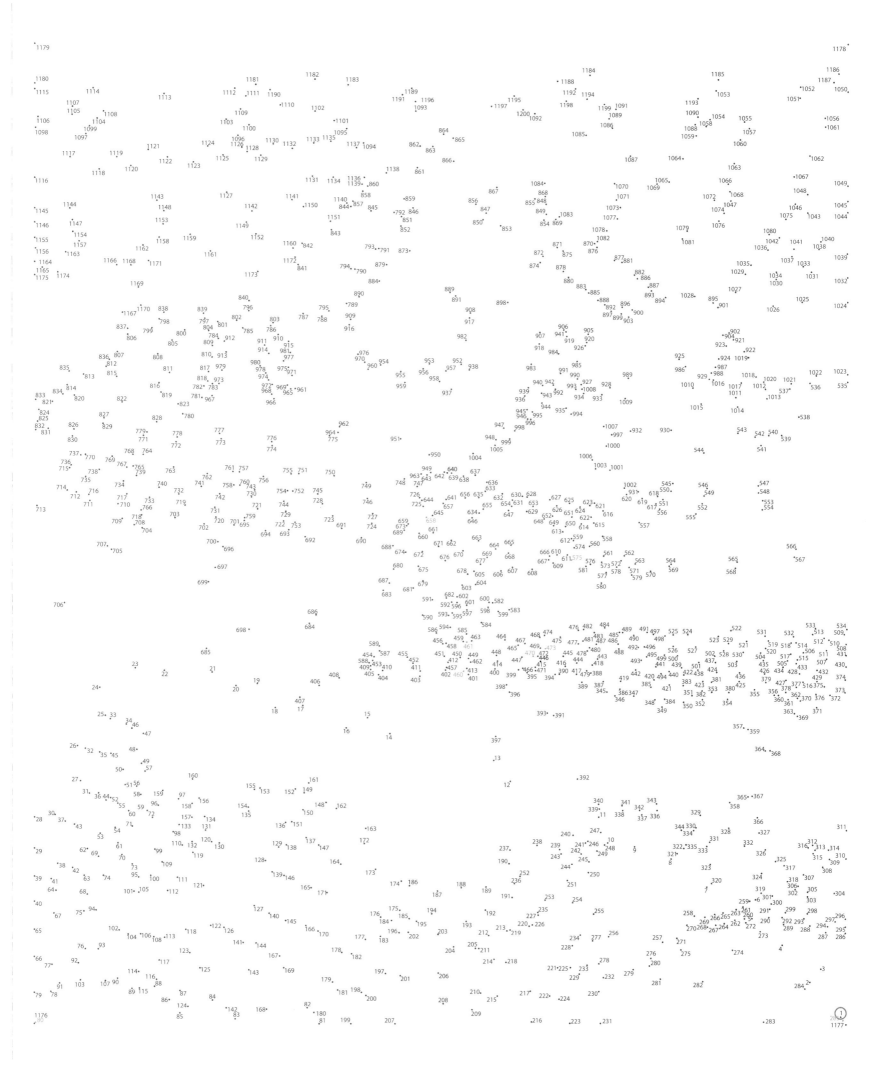

Just 30 miles outside Las Vegas stands this awesome
man-made structure. It is capable of irrigating two
million acres, generates enough electricity to power
1.3 million homes and you can drive right across its roof.

Draw it and name it!

You'll surely recognize one of the most iconic structures in the world. Here are some more clues: it is made of 18,038 pieces of wrought iron and 2.5 million rivets, has 1,665 steps and is illuminated at night by 20,000 lightbulbs.

Too easy!

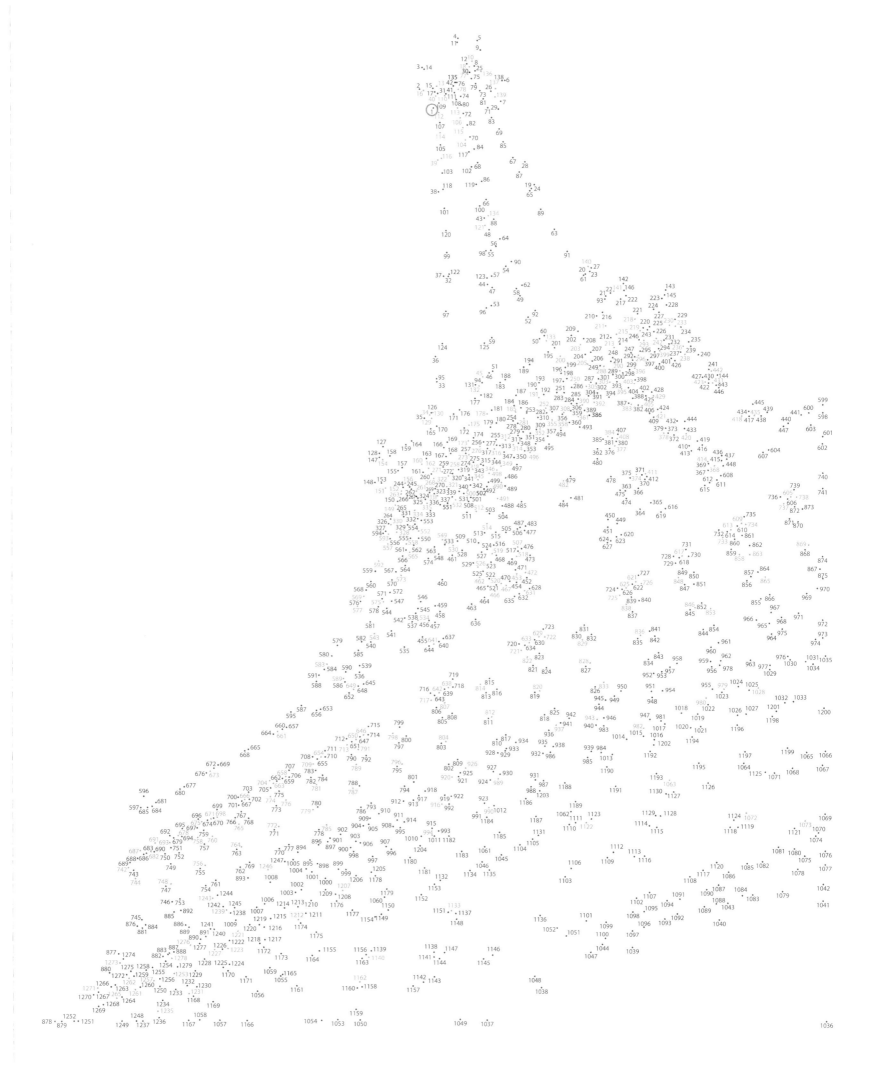

Where are we now? Built on the site of a medieval palace,
it contains the mother of all parliaments, but it is most
famous for its tower with huge clock.

Can you name the famous bell that gives the tower its name?

Perhaps the world's most recognizable cathedral,
this gothic masterpiece sits on an island in the middle
of a city. It is home to literature's most famous
bellringer, but does it ring a bell with you?

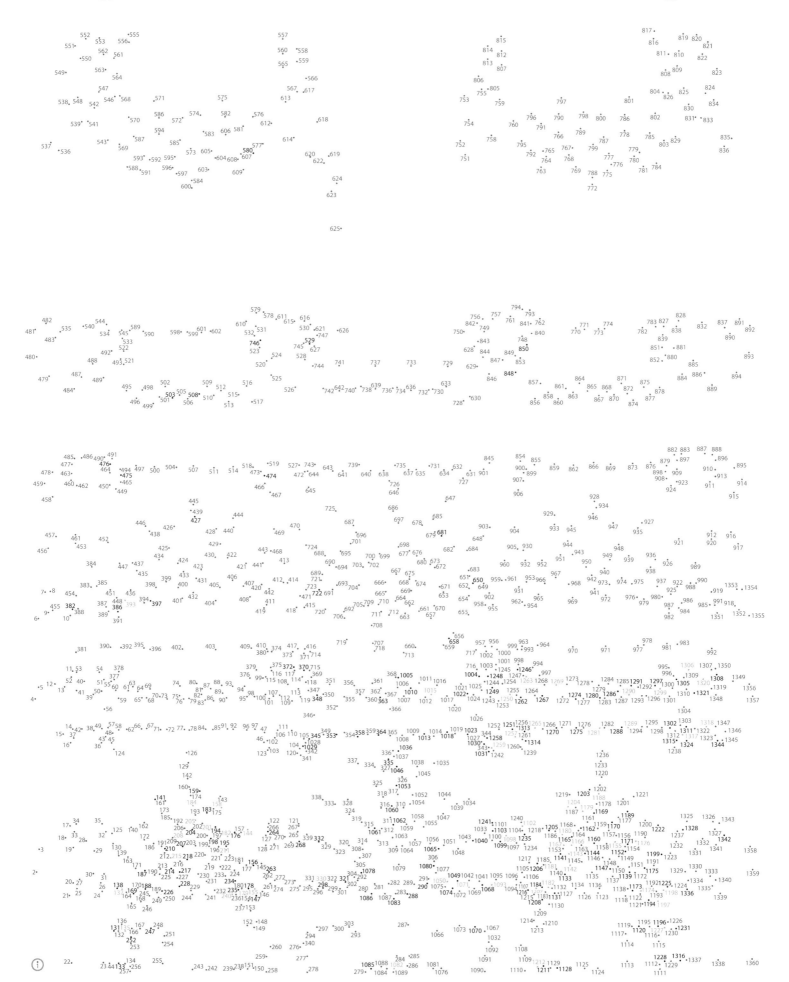

Join these dots to reveal one of the most beautiful beaches
in the world. Although it can be reached only by longtail
boat, many tourists still manage to find their way
to its pure white sandy beach.

But where in the world are we?

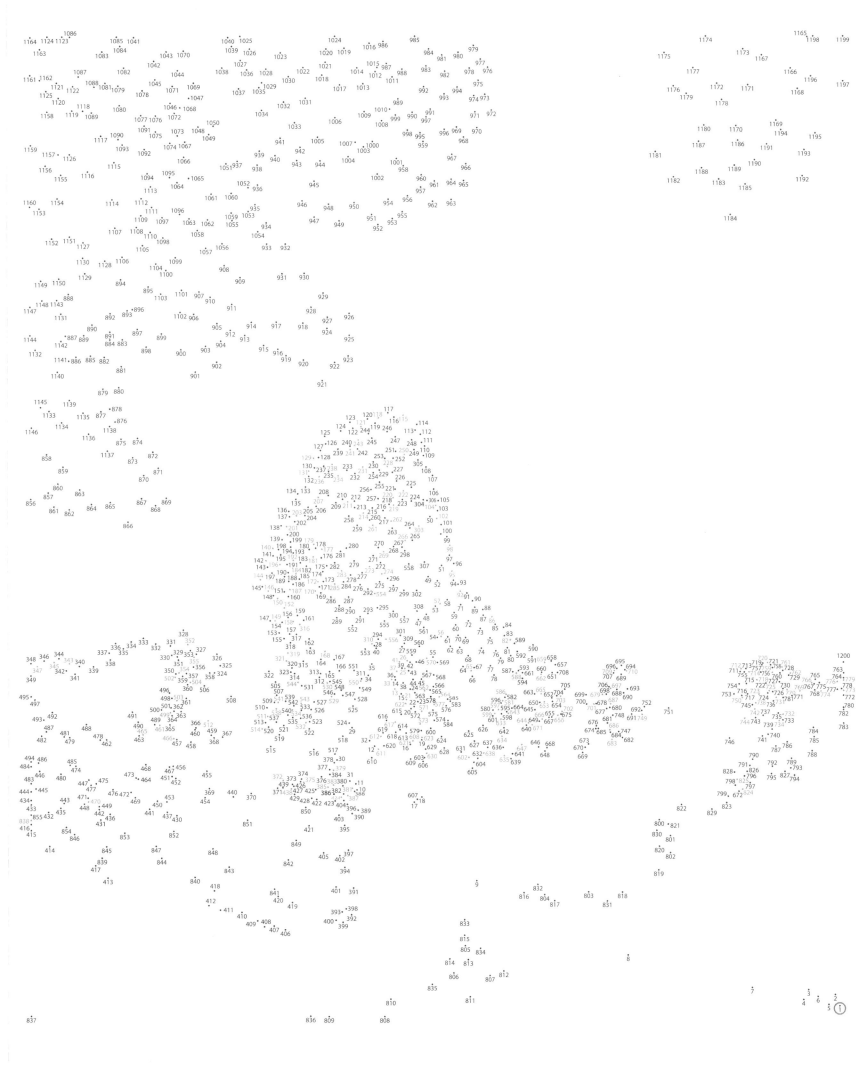

For 2,000 years these mountains on a remote Philippine island have been carefully cultivated with a seemingly endless series of hand-dug terraced fields that climb thousands of yards.

What is being grown on this amazing landscape?

In Nepal it is known as "Sagarmatha", meaning "forehead of the sky". We name it after a retired surveyor general who never even saw its iconic peak.

Can you identify it?

Nicknamed "Little Venice", this charming town has its own picturesque canals, quaint streets, colourful half-timbered houses and bustling tourists. However, you won't find it in Italy, but in a neighbouring country.

Any idea where?

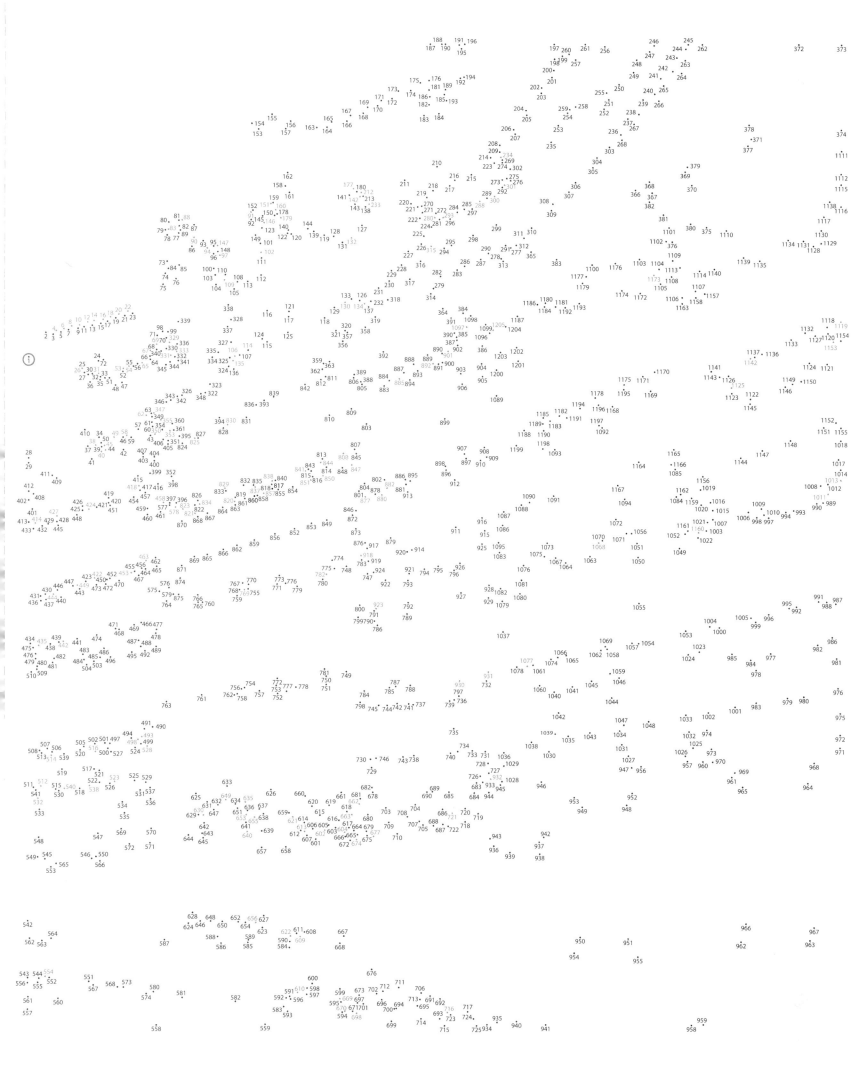

The goddess of wealth, happiness, wisdom and music is the inspiration for this structure that stands at the foot of a mountain, next to a mass of ferns and a beautifully still pool.

Where would you travel to if you wanted to visit this site?

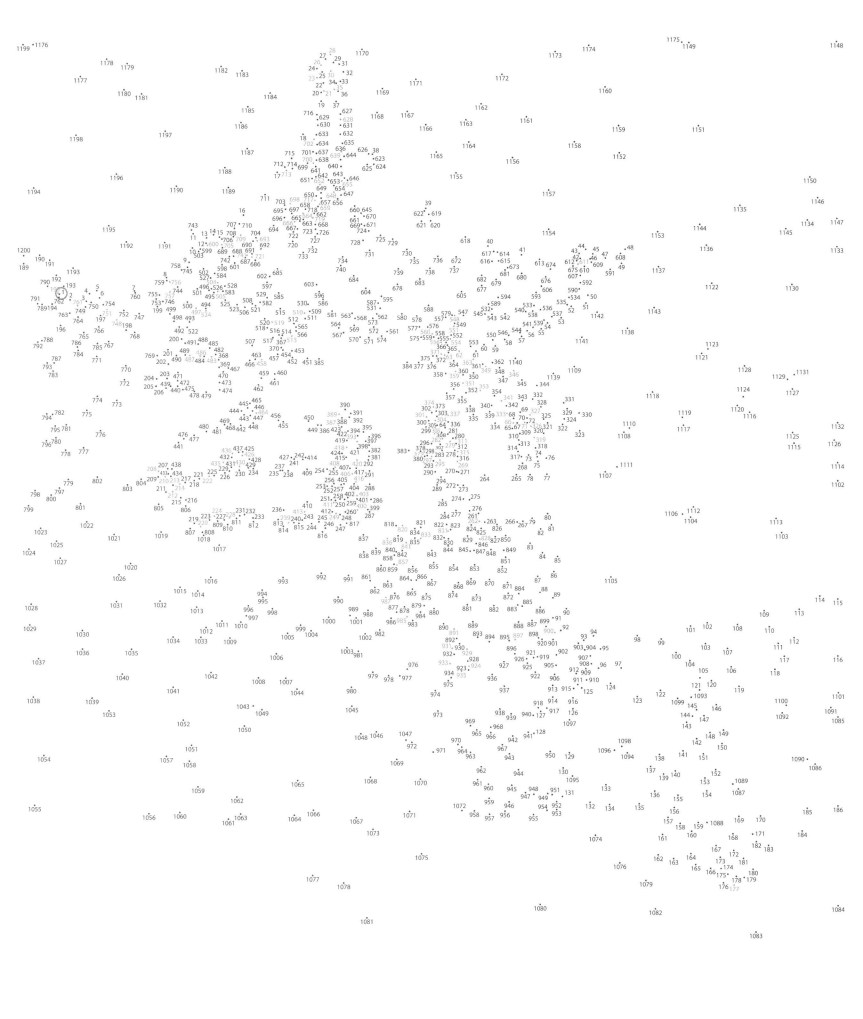

Straddling Brazil and Argentina, this incredible natural
wonder is set in an area of subtropical rainforest
and stretches for almost two miles.

Your drawing will reveal what it is, but
can you name this iconic destination?

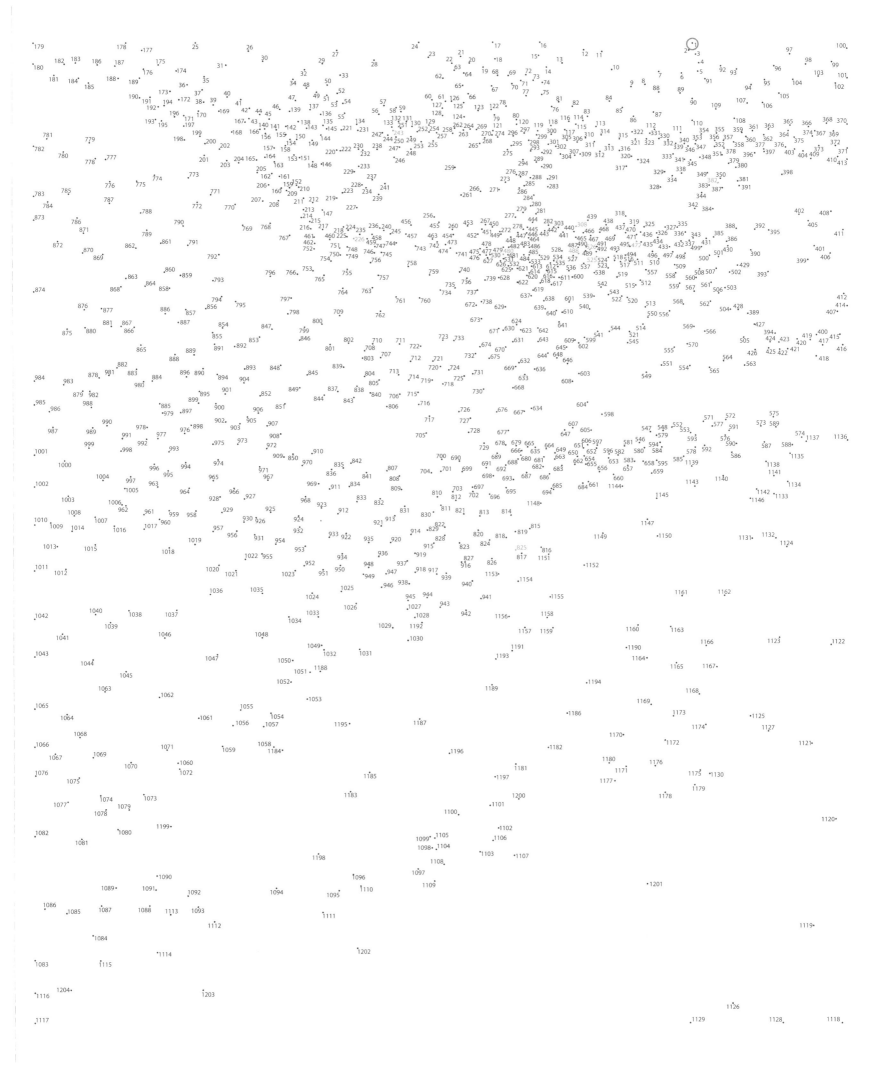

Picturesque "case torri", or tower houses, rise up the steep hillside from the clear blue waters of the tiny harbour. This is the southernmost of the Italian Riviera's Cinque Terre towns.

But do you know what it is called?

Perched on a hill, high above the Tibetan capital Lhasa, this is the most monumental building in all Tibet. It has 13 storeys, 1,000 rooms and is the traditional home of the Dalai Lama.

Can you give his address?

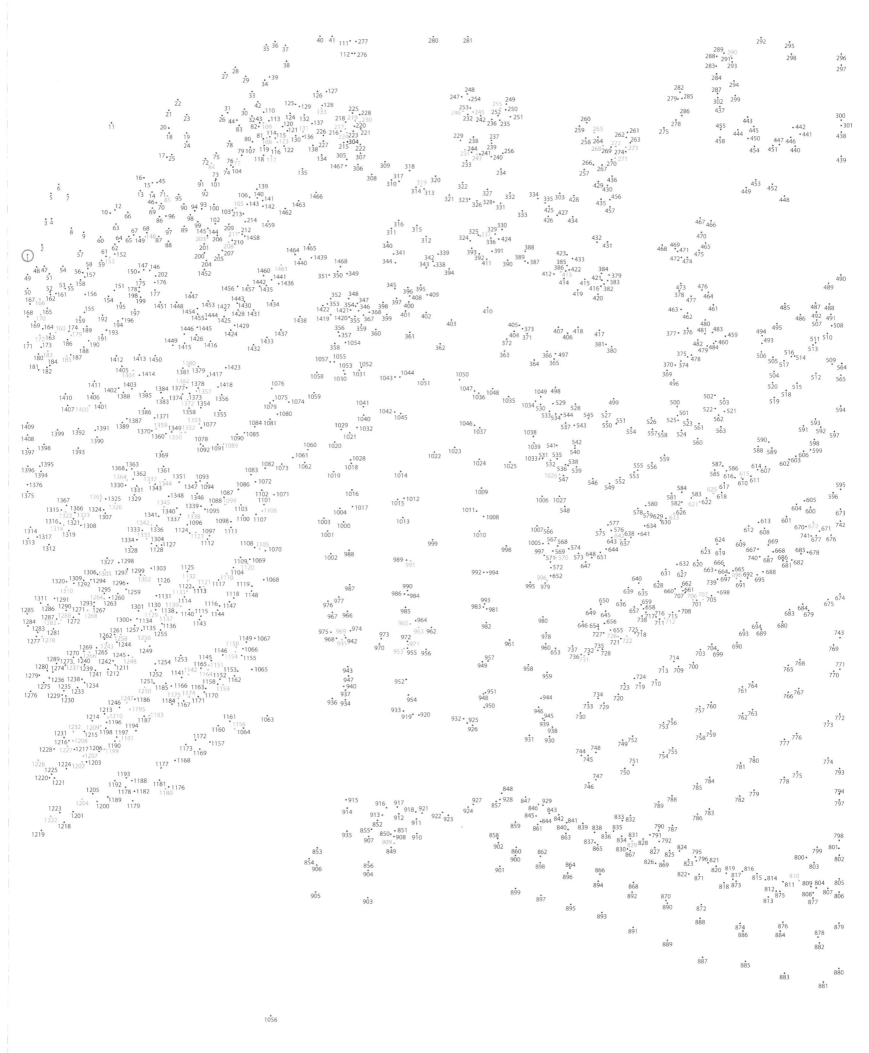

It's hot. It's humid. It covers more than 2.1 million square miles, contains 1,300 types of bird and is home to more than 438,000 different plants. It's a truly amazing environment.

But where exactly are you?

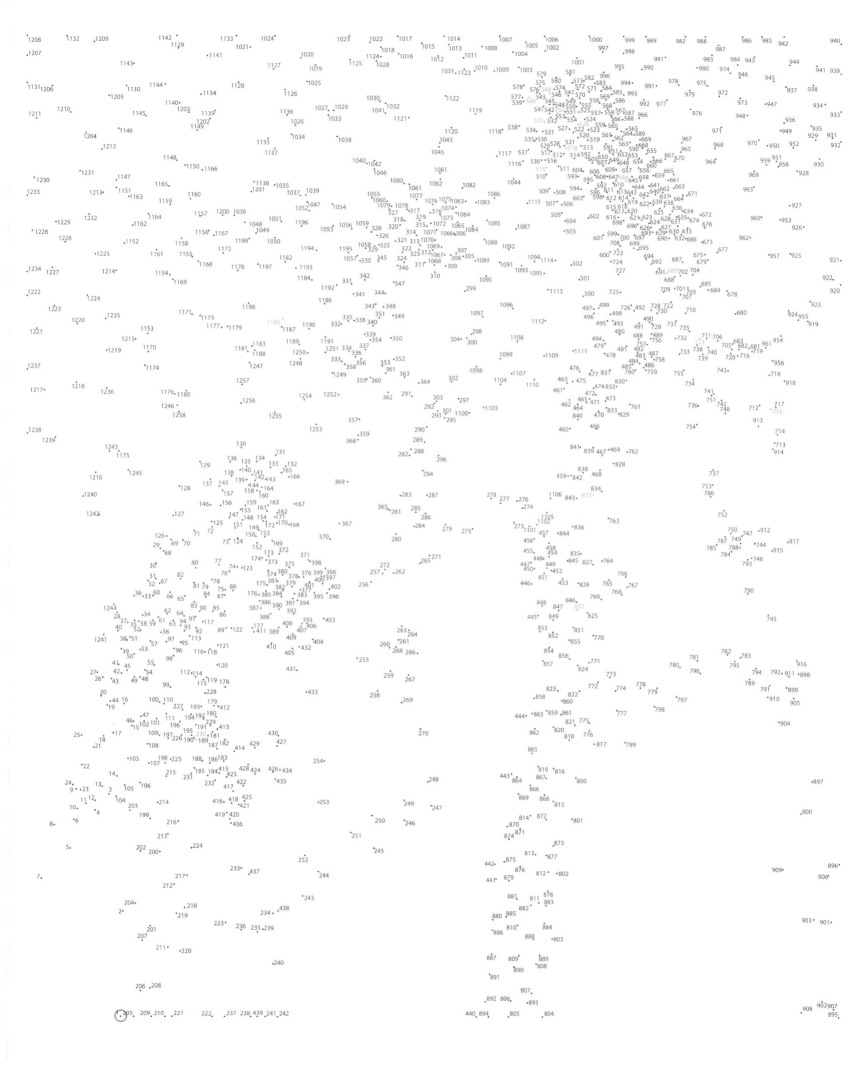

The largest religious monument in the world, this
magnificent and well-preserved building was built
by King Suryavarman II in the early twelfth century
and appears on its country's national flag.

Join the dots to reveal its glory!

The incredibly opulent architecture and décor are among this city's major attractions and their extravagant lights make this the brightest place on Earth when looked at from outer space.

Where do more than 40 million visitors flock every year?

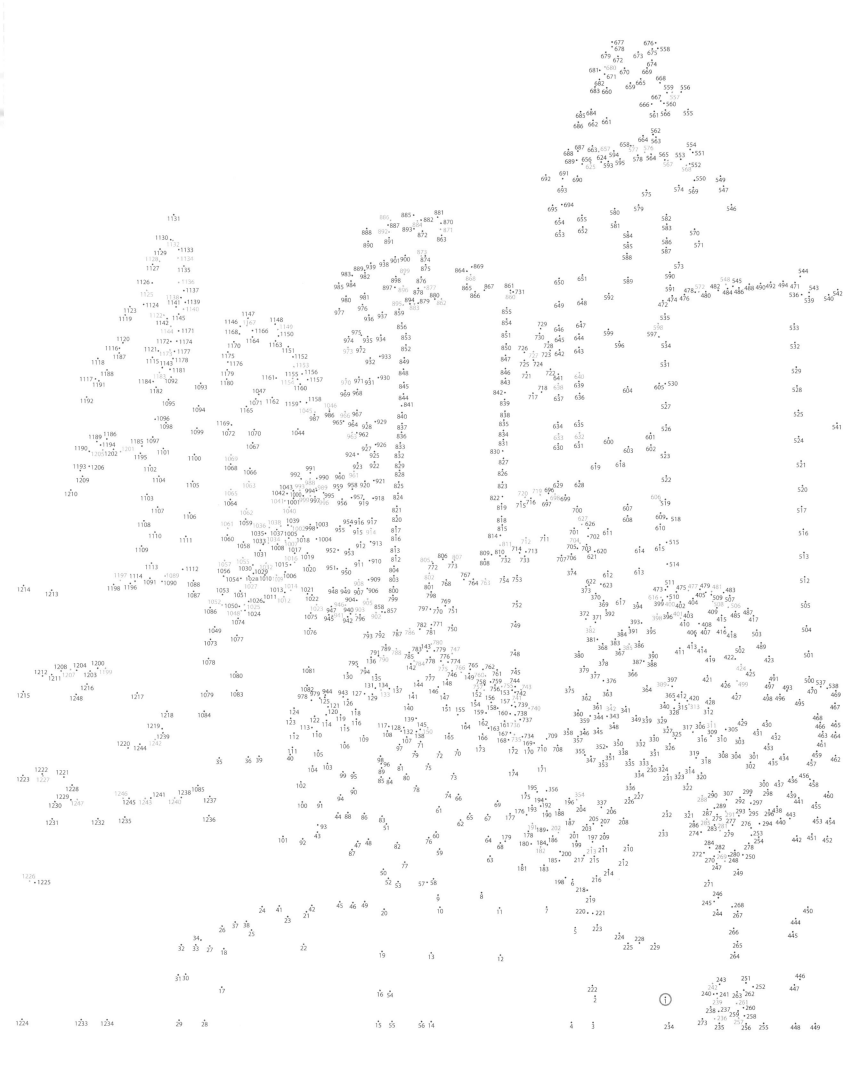

This is a beautiful religious building in the largest area of Buddhist temples, pagodas, shrines and ruins in the world. It features incredibly intricate architectural designs on both the interior and the exterior.

What is the name of this temple?

It sits beneath the turquoise waters of the Caribbean Sea
and is home to hundreds of species of coral, more
than 500 species of fish and is the second largest
of its kind in the world.

What – and where – is it?

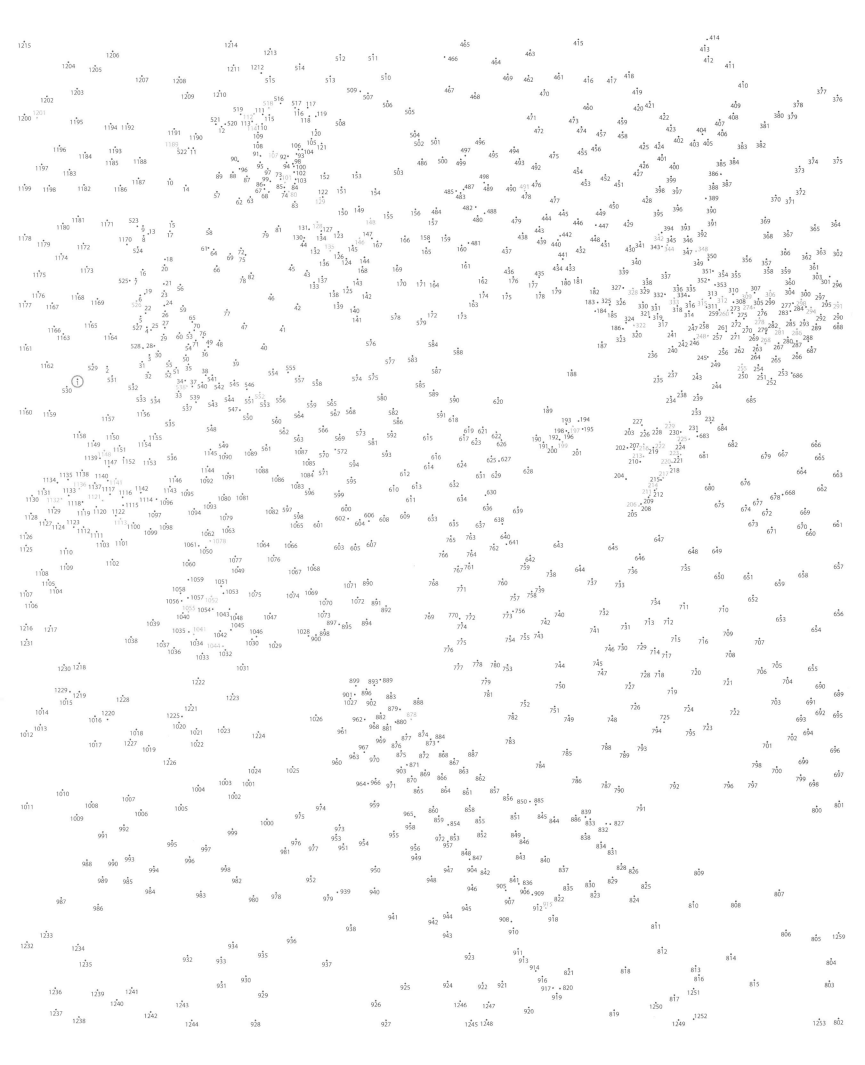

On the northern coast of Puerto Rico, this place is protected by two forts and linked to the mainland by three bridges. Its charm derives from its cobbled streets and bright, flat-roofed buildings.

Can you identify this city?

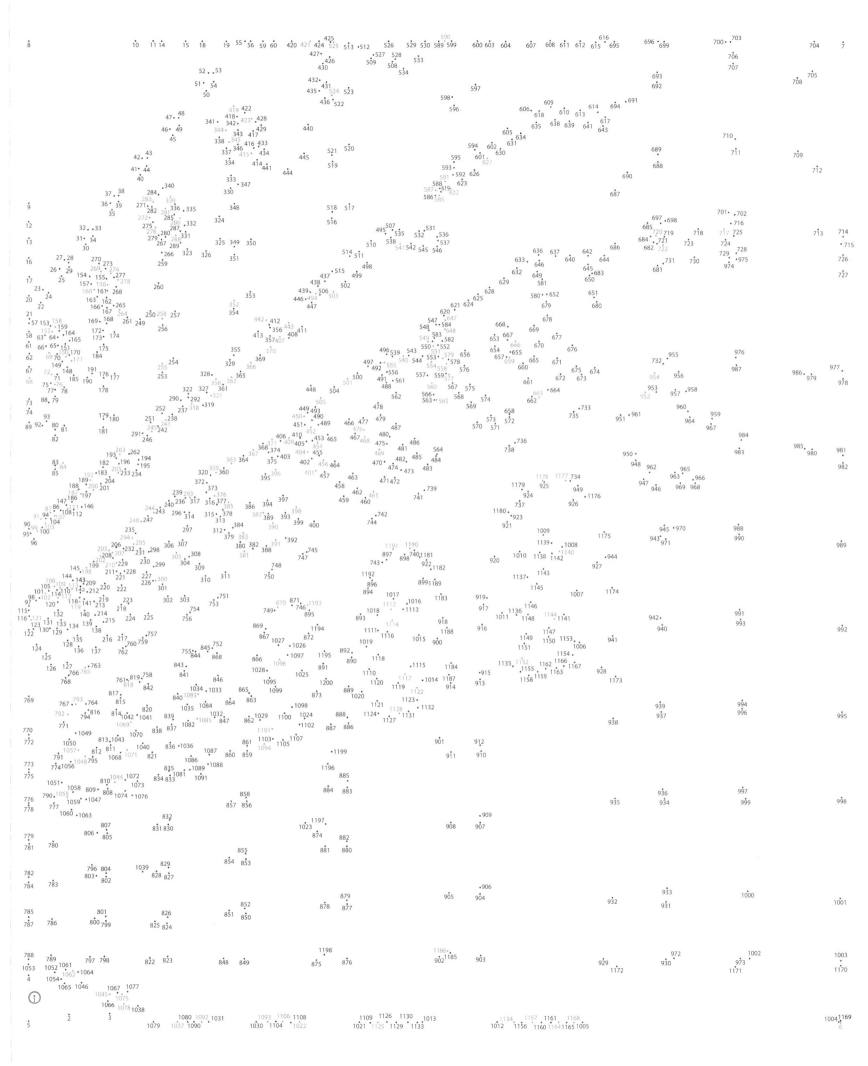

Perfectly preserved medieval streets, a thirteenth-century
cathedral and breathtaking views around every corner
make this Sicily's most popular tourist destination. Ovid,
Goethe and D H Lawrence all came here to work.

What's the town that has inspired so many writers?

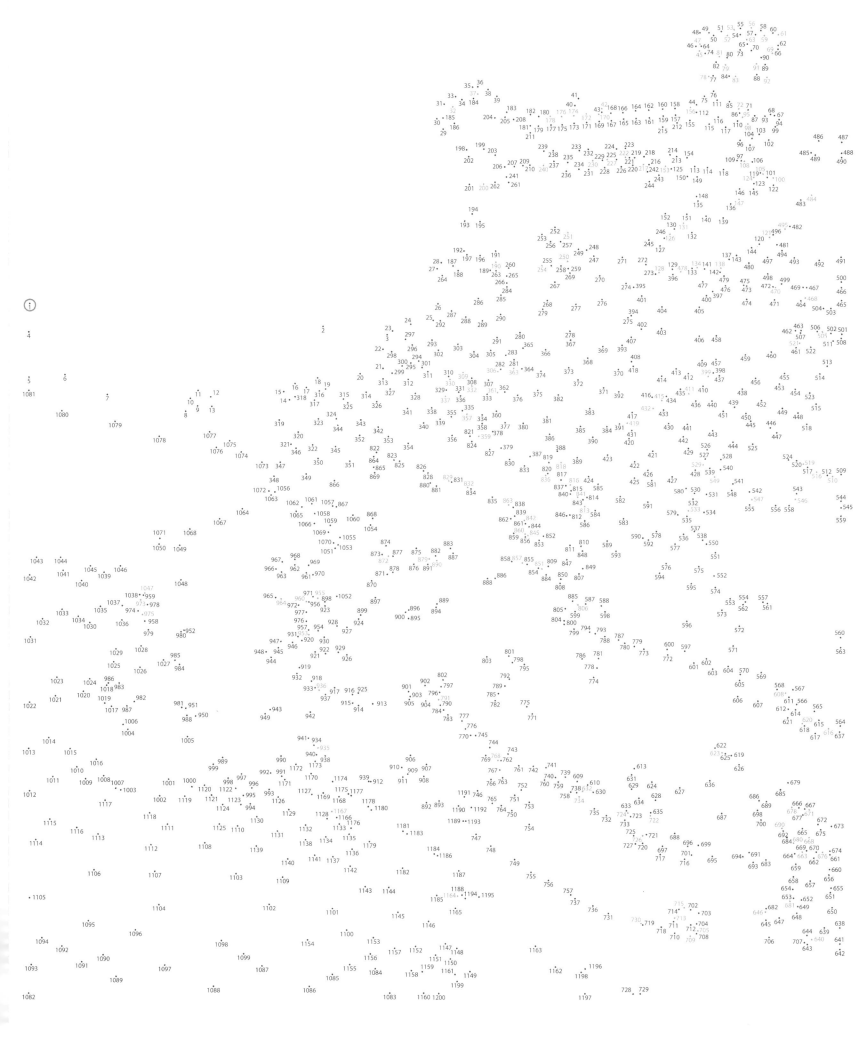

Originally built as a mausoleum for Emperor Diocletian, this building was converted into a place of worship in the seventh century. Its bell tower is the emblem of the city.

But what is it and where can you find it?

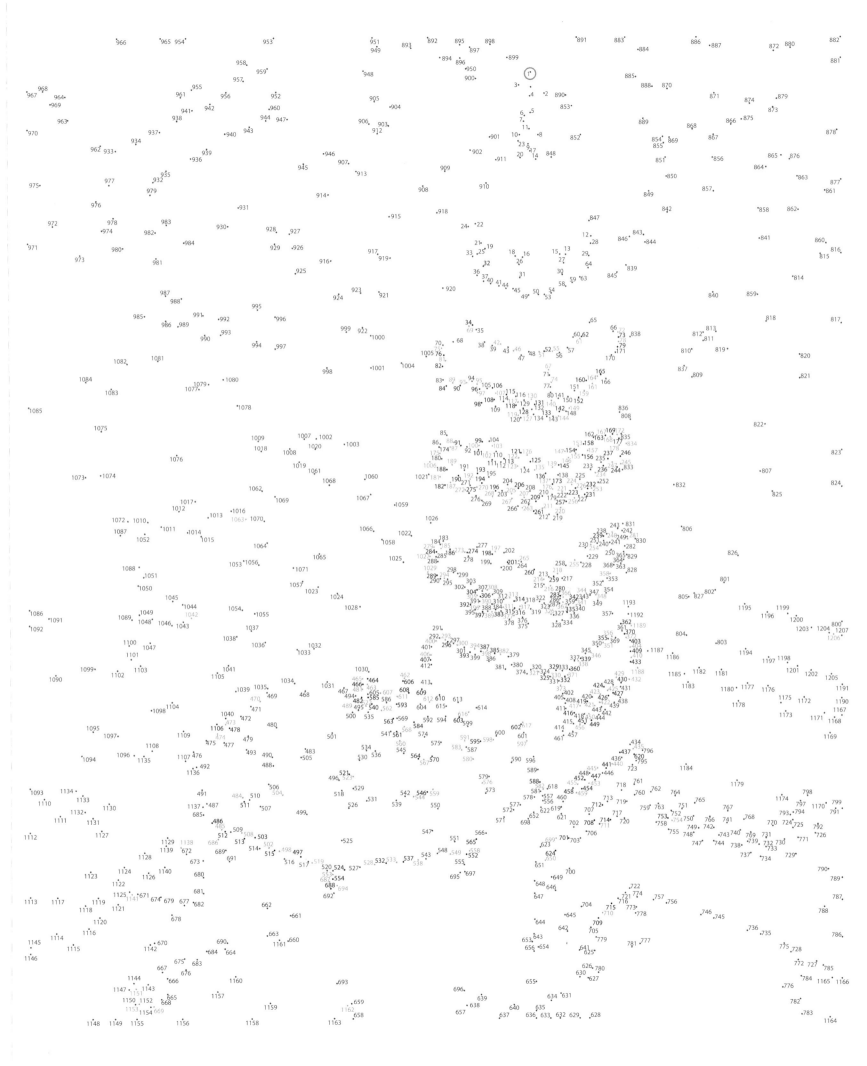

At the foot of the Jungfrau, with the Eiger looming over it, this place offers amazing views of the Swiss Alps. In the mid-nineteenth century it became one of the first alpine resorts.

What is this picture-postcard village called?

On one side it boasts crystal-clear blue waters, while inland the breathtaking, cloud-engulfed Table Mountain looks down on it. In between lie pretty gabled homesteads, Georgian mansions and Victorian terraced homes.

Do you know where you are?

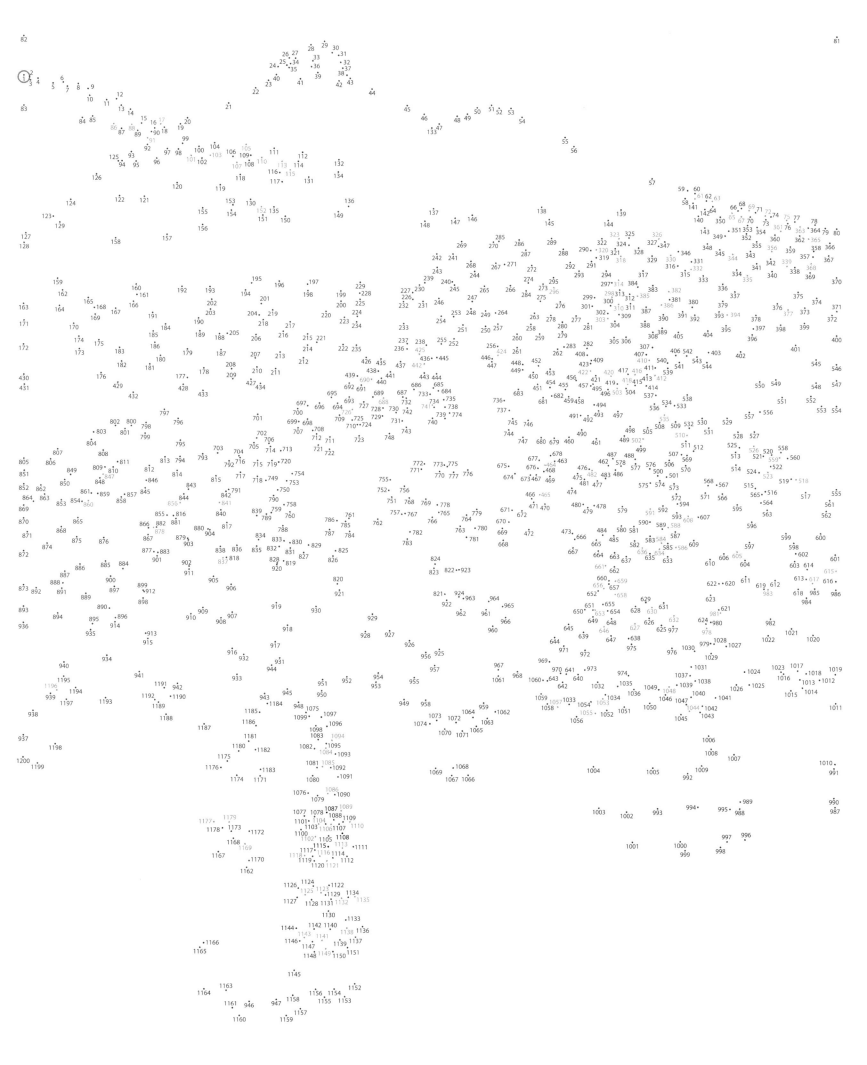

An 1886 gift from France to the United States, this statue
features a female figure holding a torch and a tablet inscribed
with the date of the American Declaration of Independence.

Can you identify this famous monument?

There are more than 8,000 of them. They are usually around 6 feet tall, but no two are exactly alike, varying in age, rank, facial features, hairstyle and even expression. They were created for the burial tomb of Emperor Qin Shi Huang, the first emperor of China.

Who are they?

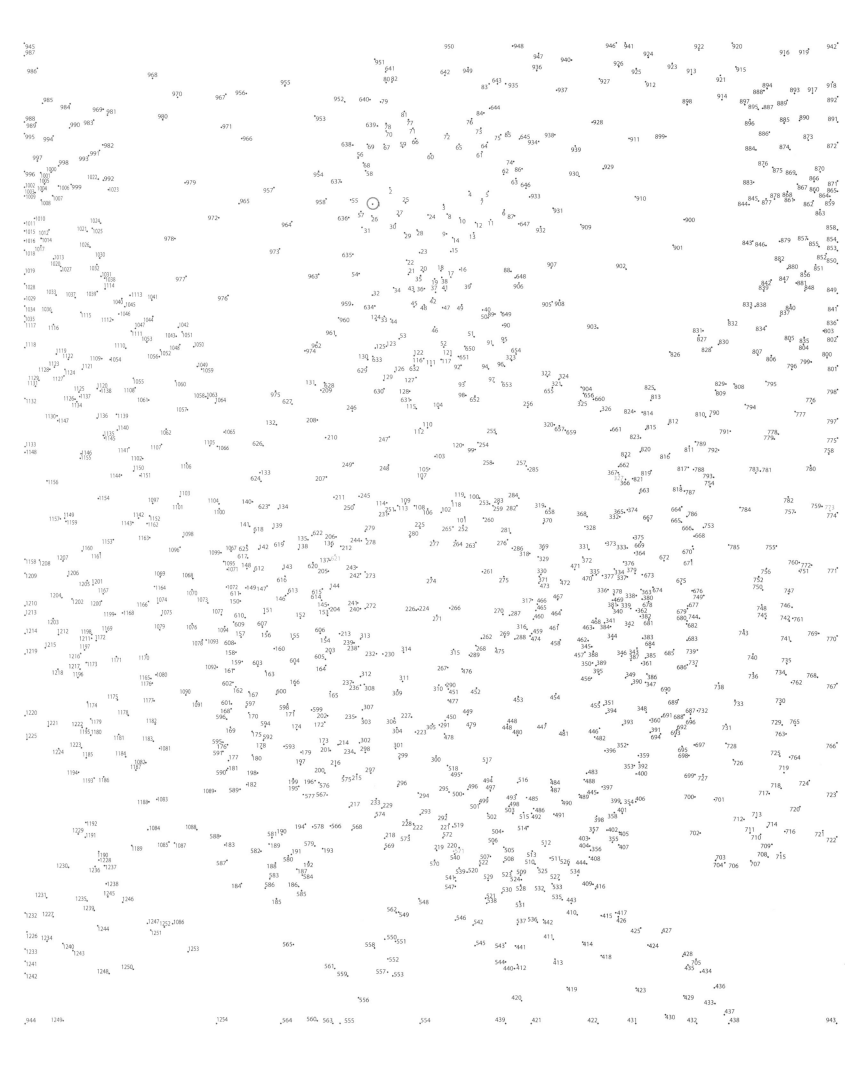

America's oldest protected outdoor area extends
63 miles north to south and 54 miles east to west.
Situated on a dormant volcano, it contains geysers
and grottos, as well as a wide range of wildlife.

What is this amazing place?

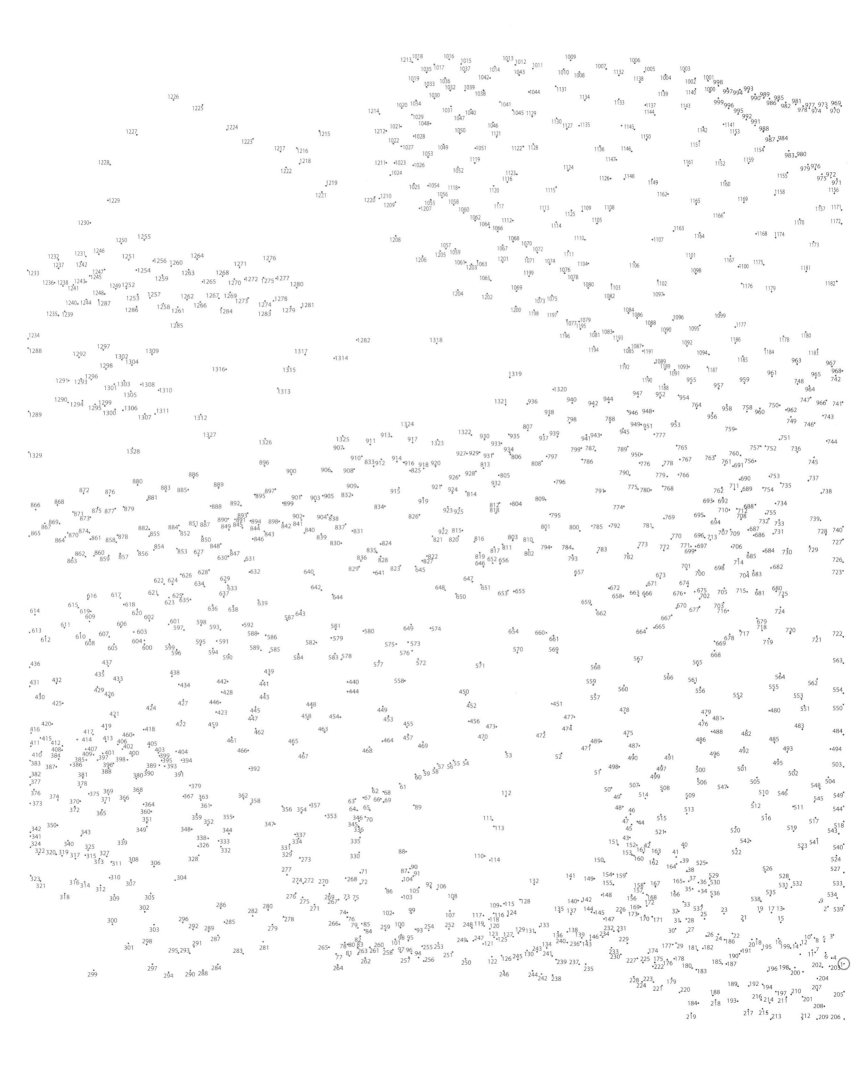

Take a stroll around the oldest city in Georgia.
It boasts an incredibly well preserved historic district
with pristine townhouses that encompass 200 years
of architectural style, including neo-Gothic,
Italianate palazzo and French Second Empire.

Where are you wandering?

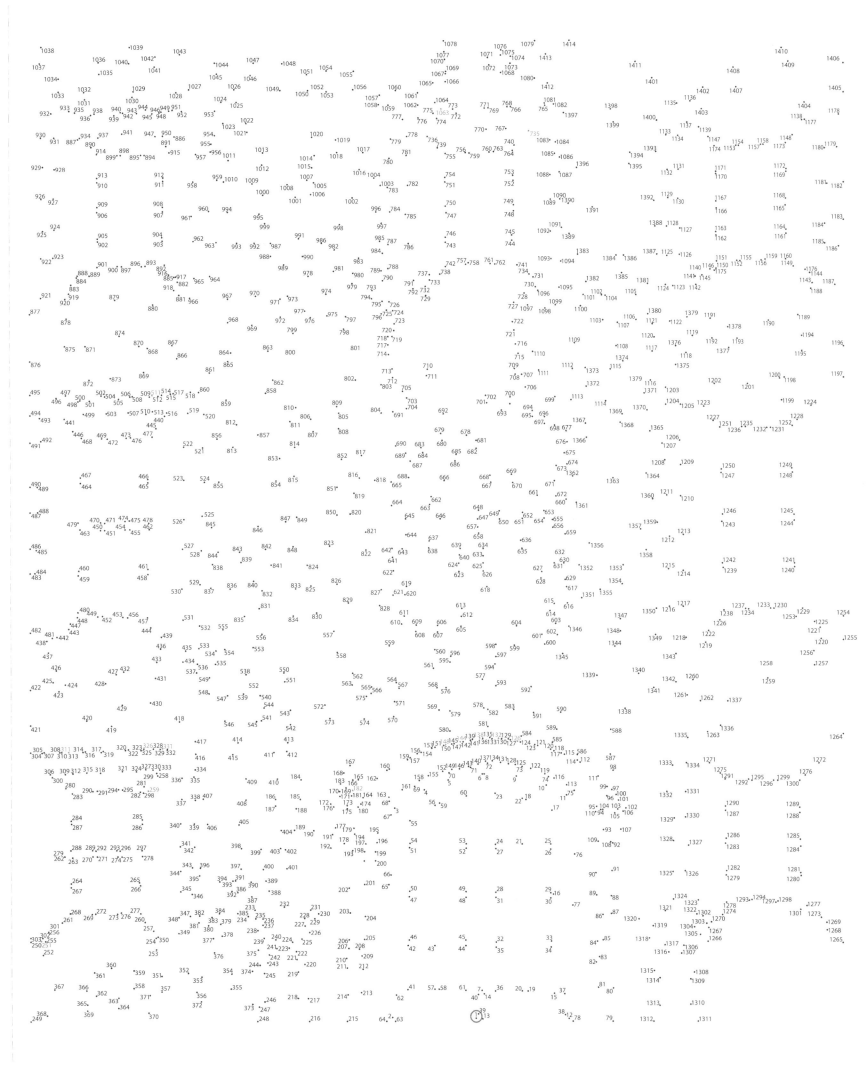

This amazingly sophisticated civilization flourished between 300 and 900 CE across southern Mexico, Guatemala, Honduras and northern Belize. Do you know what it was called? These are some of its most impressive ruins.

Do you know where they are?

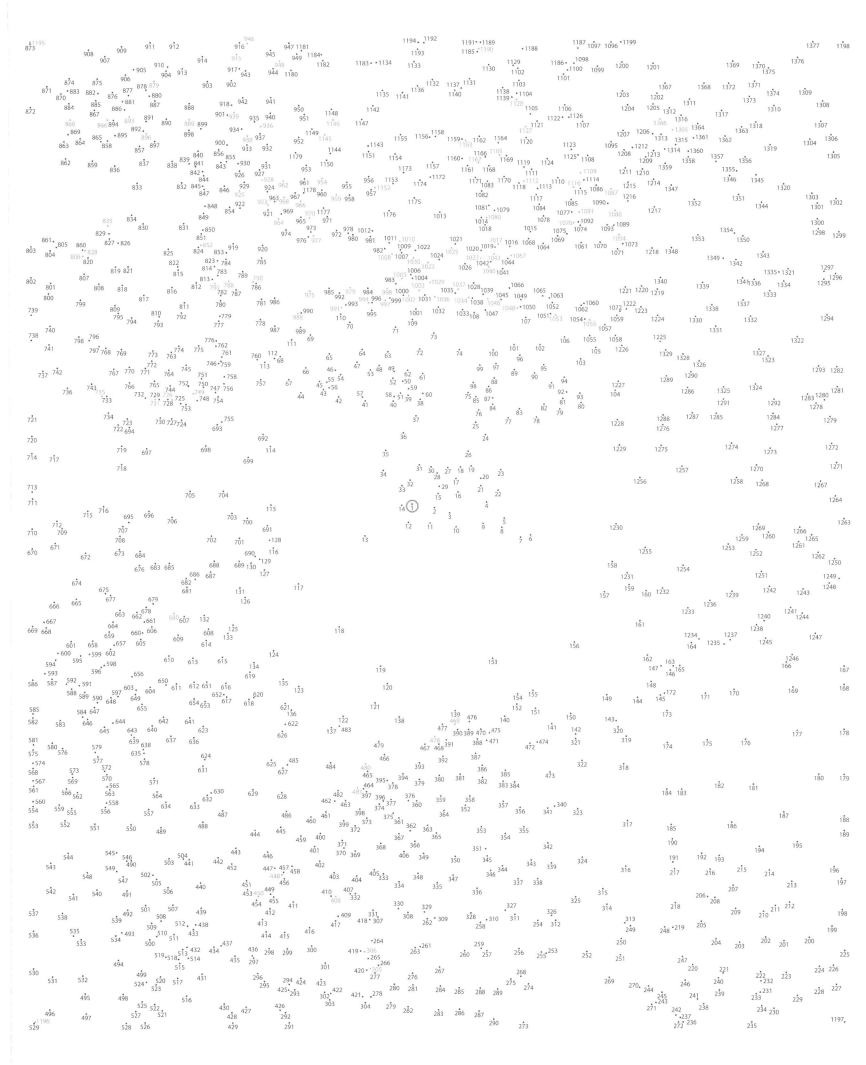

When it originally opened, it offered a crucial shortcut between the Atlantic and the Pacific Ocean, and it continues to do that today, with around 14,000 ships using it every year.

What is it?

Towering high above Manhattan, this 102-floor
glittering silver skyscraper is constructed out
of 10,000,000 bricks. It is struck by lightning
approximately 100 times every year.

Can you name this famous landmark?

Designed by America's most famous architect,
Frank Lloyd Wright, for the Kaufmann family, this
house is situated in a stunning location, above a waterfall
that flows down the Allegheny Mountains in Pennsylvania.

What is the name of this iconic house?

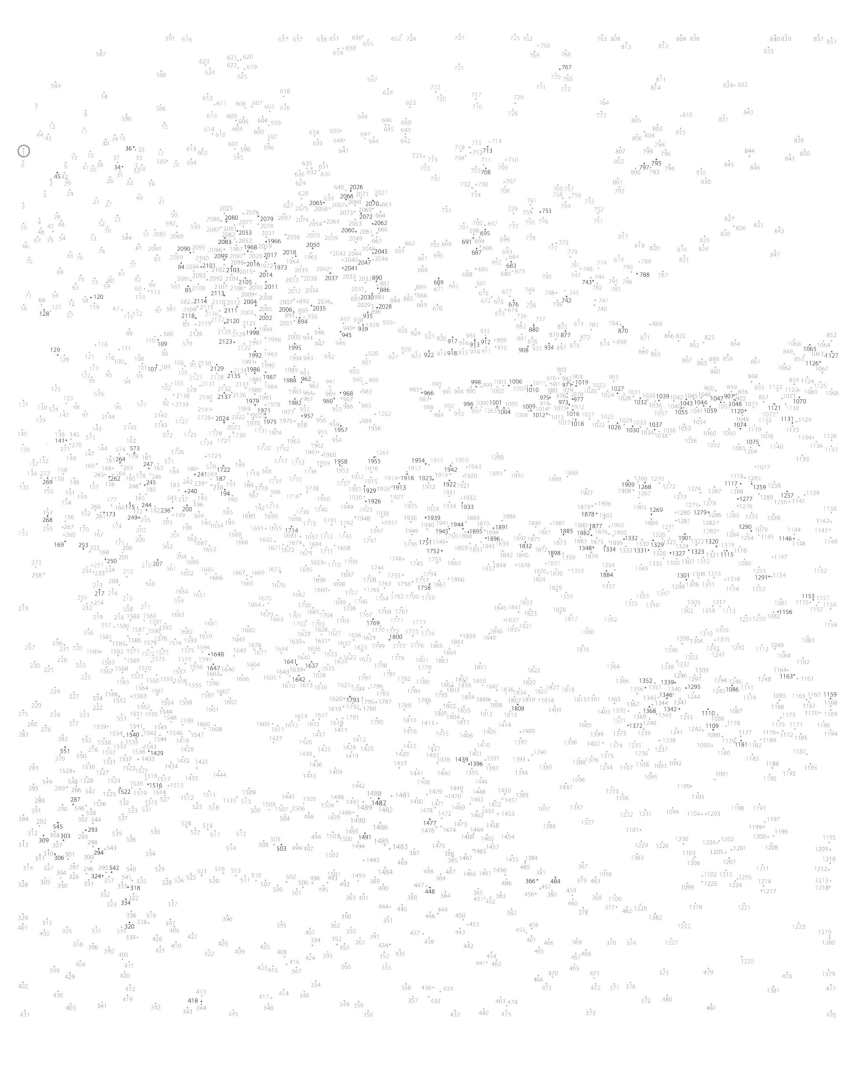

This neo-Gothic building in Indiana was completed in 1870.
It features a bell tower that's higher than 200 feet,
and interior ceilings that soar to nearly 60 feet, and
there are 44 large stained glass windows.

Can you identify this beautiful university church?

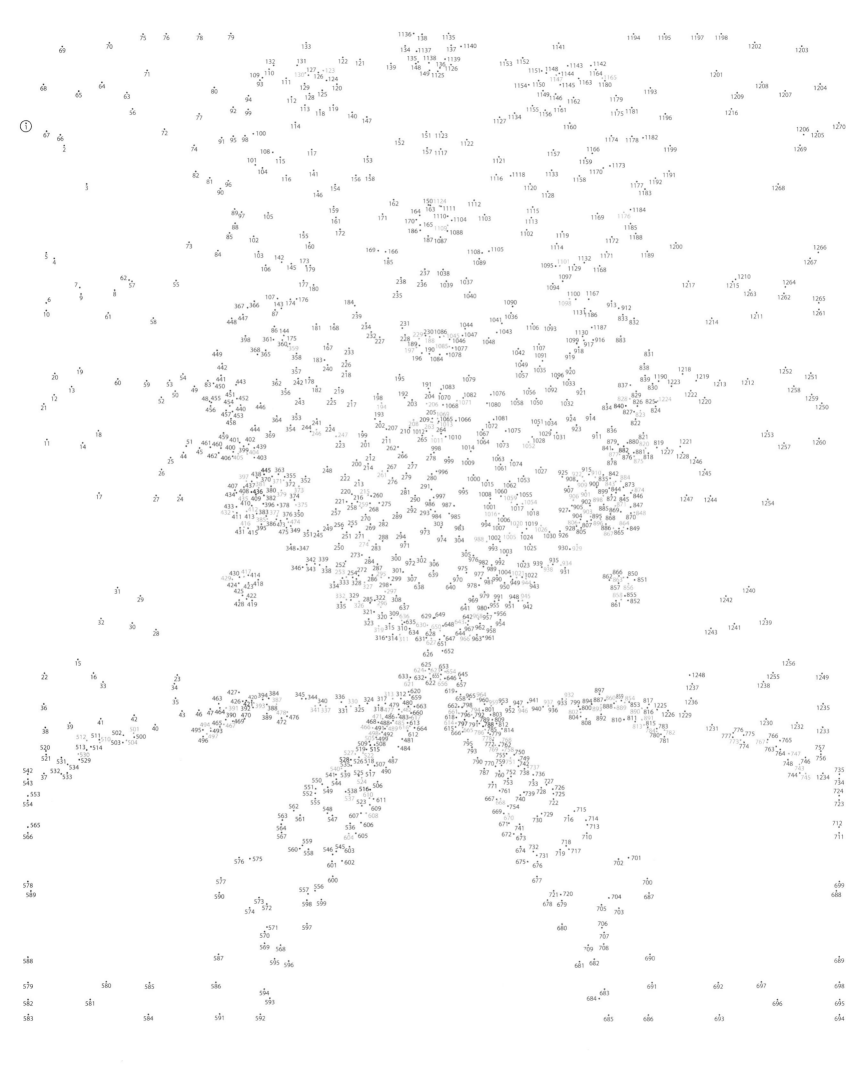

Designed by modernist Spanish architect Antoni Gaudí, it's not finished yet, but when it is – in 2026 – it will have 18 towers and will accommodate 13,000 people.

What is this church with an unconventional shape?

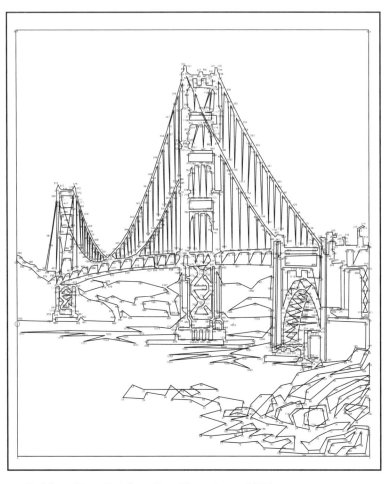

1. Golden Gate Bridge, San Francisco, USA

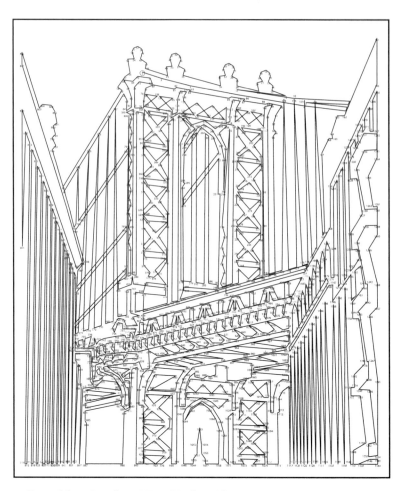

2. Brooklyn Bridge, New York, USA

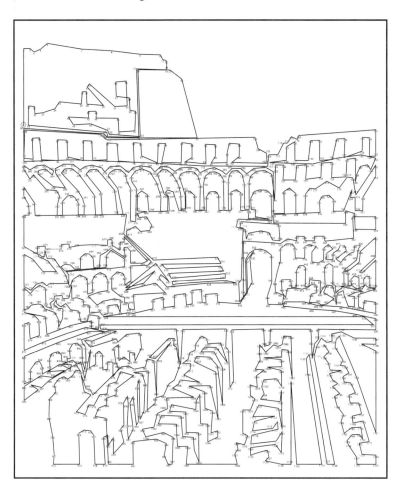

3. The Colosseum, Rome, Italy

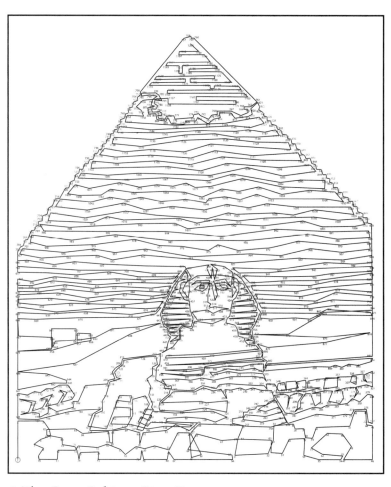

4. The Great Sphinx, Giza, Egypt

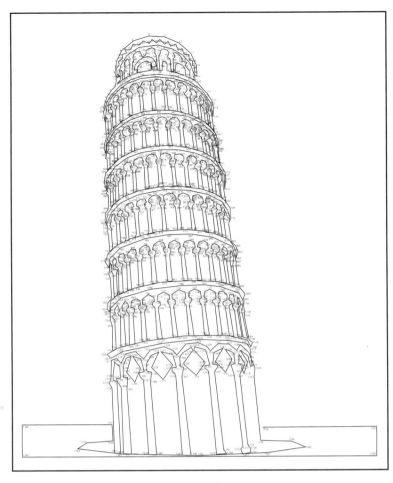

5. The Leaning Tower of Pisa, Italy

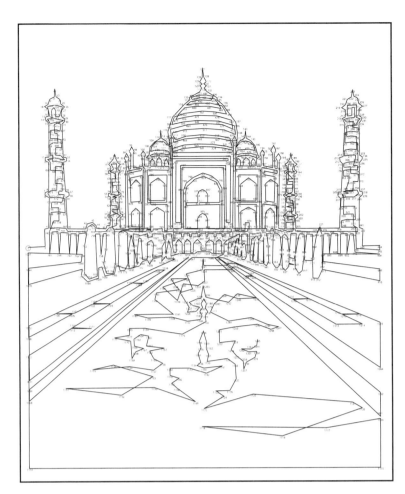

6. Taj Mahal, Agra, India

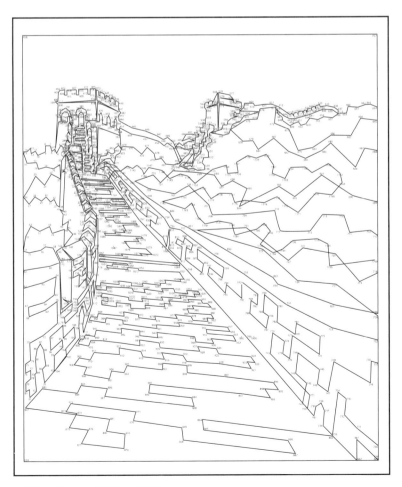

7. The Great Wall of China

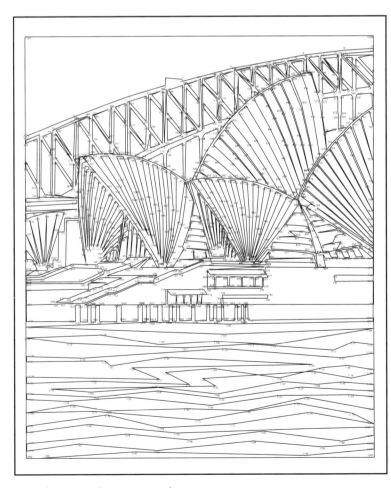

8. Sydney Harbor, Australia

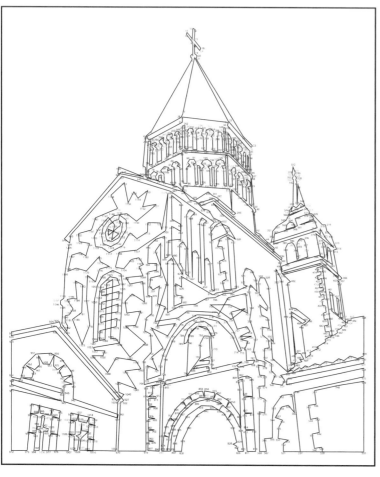

9. Cluny Abbey, Saône-et-Loire, France

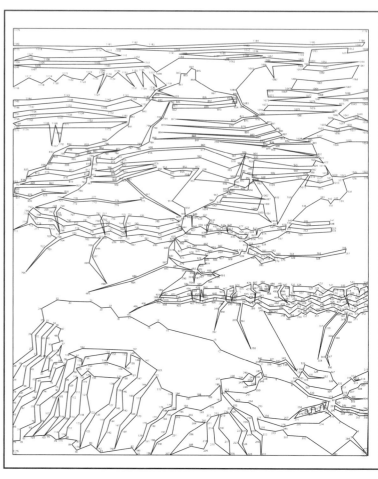

10. Grand Canyon, Arizona

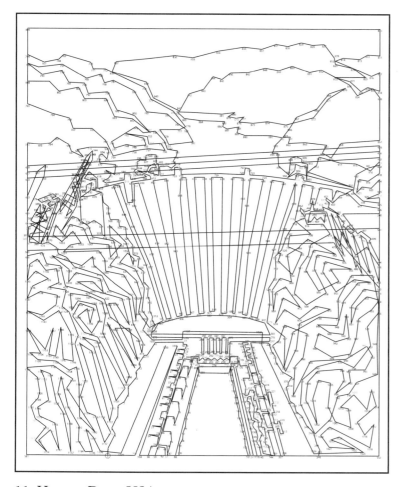

11. Hoover Dam, USA

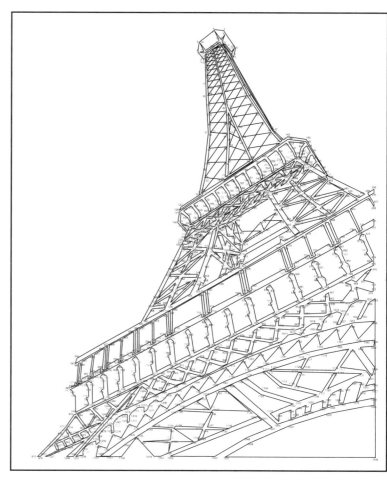

12. Eiffel Tower, Paris

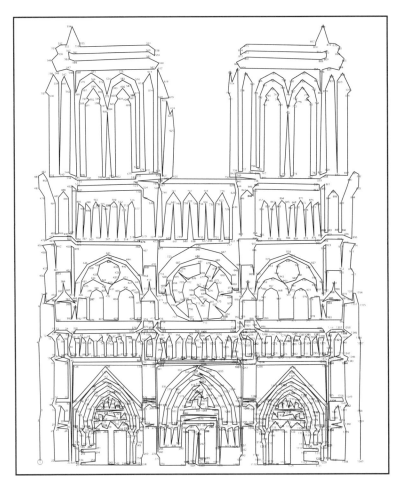

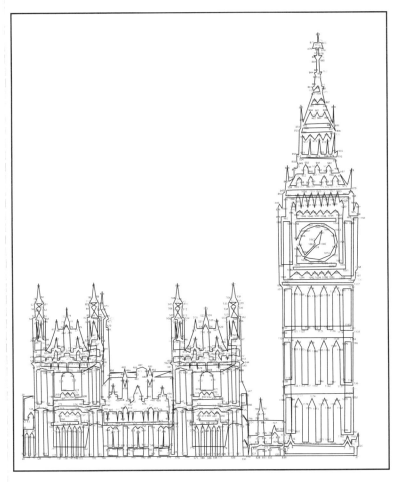

13. The Houses of Parliament, London

14. Notre Dame, Paris, France

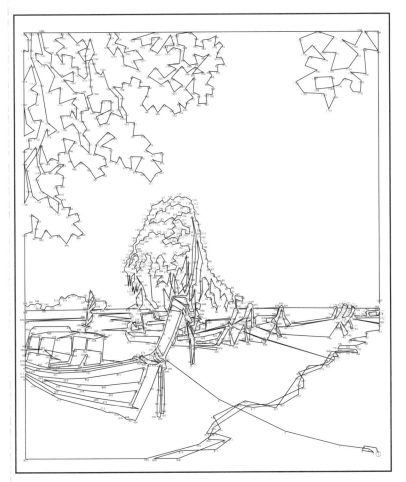

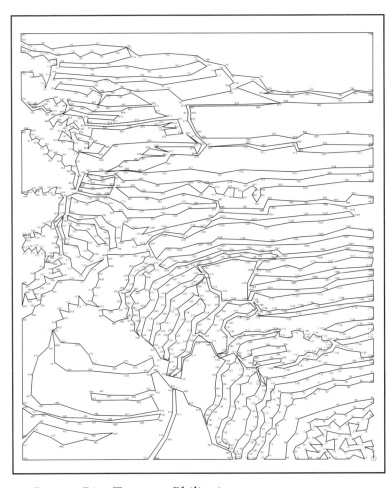

15. Phra Nang Beach, Thailand

16. Banaue Rice Terraces, Philippines.

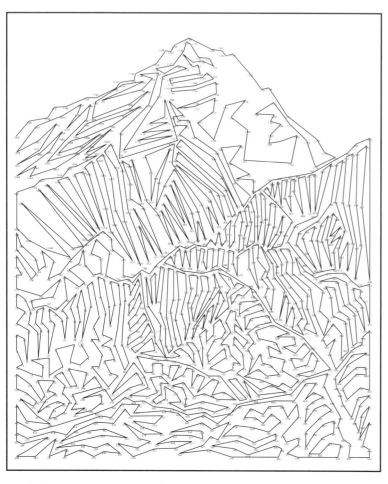

17. Mount Everest, Nepal

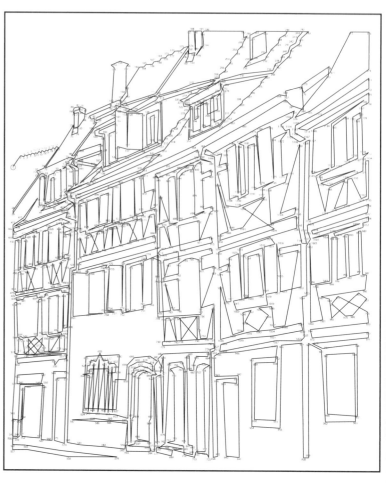

18. Colmar, Alsace, France

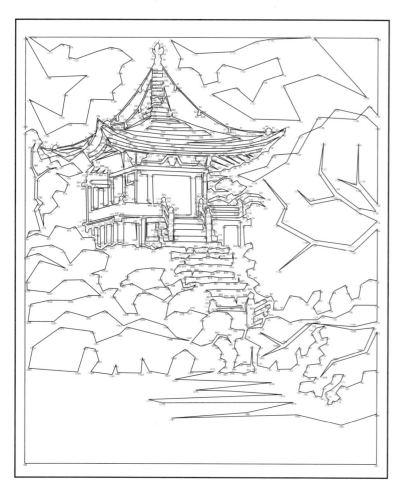

19. Daigoji Temple, Kyoto, Japan

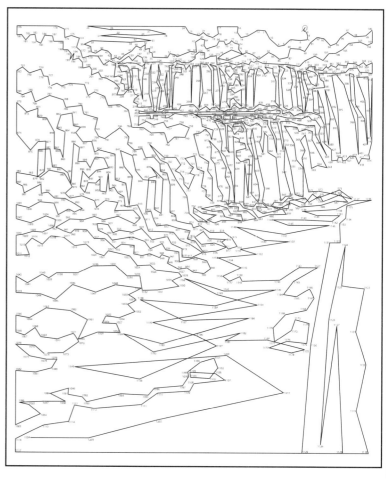

20. Iguazu Falls, South America

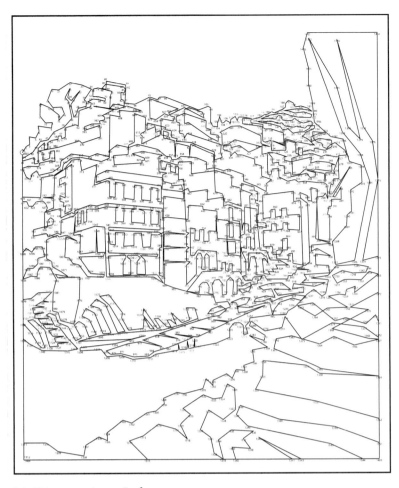

21. Riomaggiore, Italy

22. Potala Palace, Lhasa, Tibet

23. Amazon Rainforest, Brazil

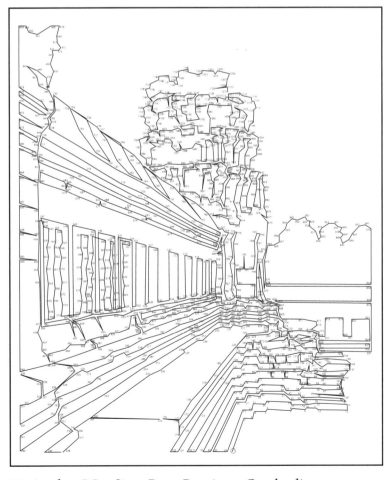

24. Angkor Wat, Siem Reap Province, Cambodia

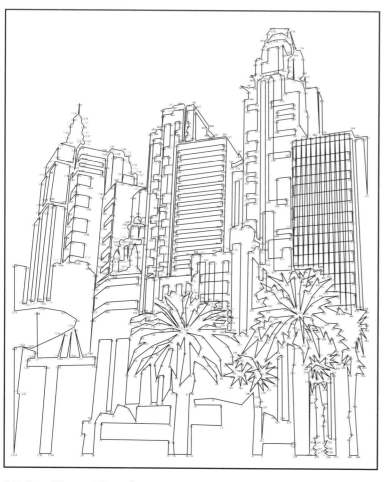

25. Las Vegas, Nevada

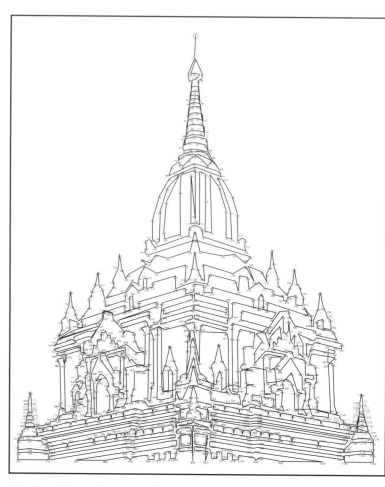

26. Gawdawpalin Temple, Bagan, Myanmar

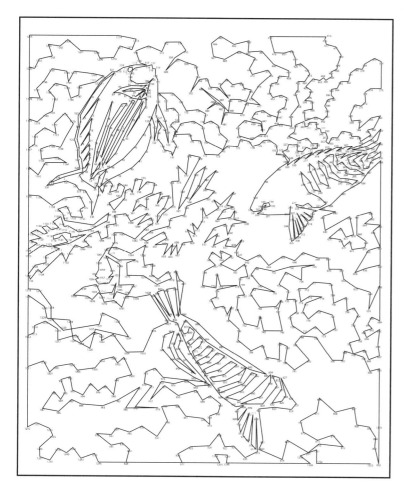

27. Belize Barrier Reef

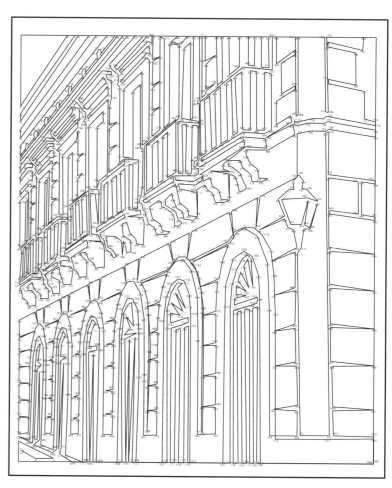

28. San Juan, Puerto Rico

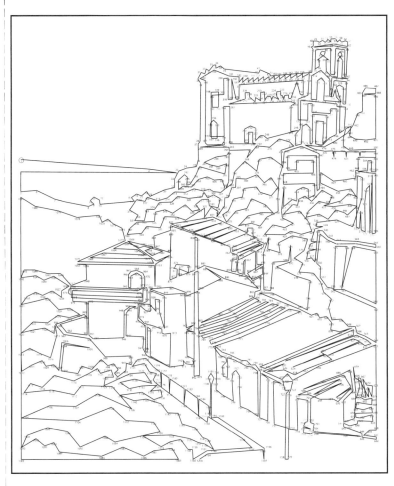

29. Taormina, Sicily, Italy

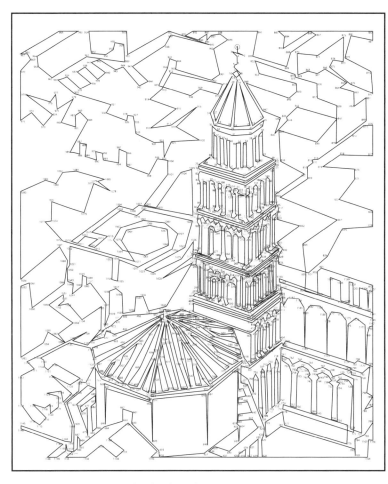

30. St Domnius Cathedral, Split, Croatia

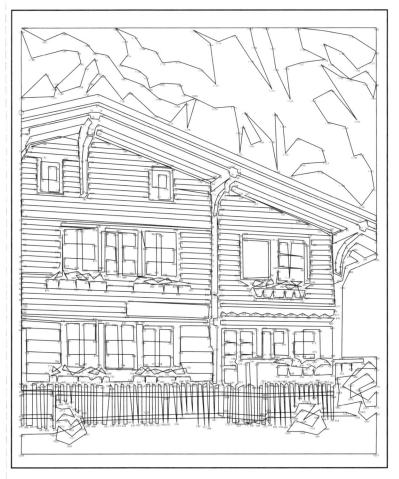

31. Wengen, Switzerland

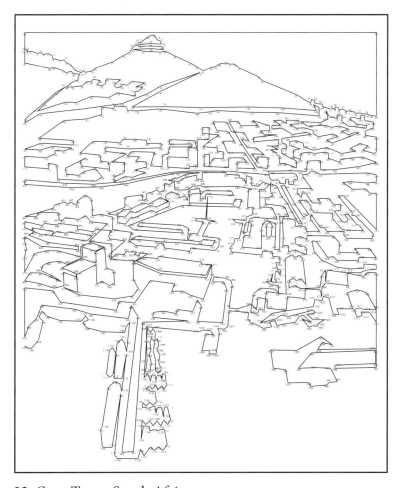

32. Cape Town, South Africa

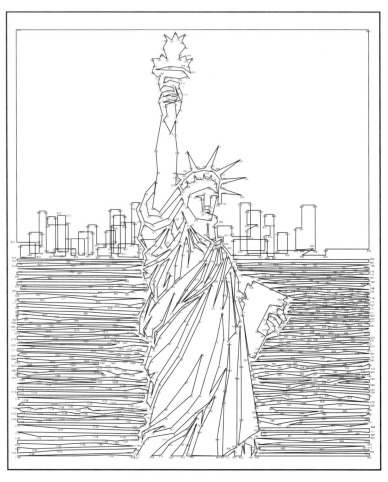

33. The Statue of Liberty, New York, USA

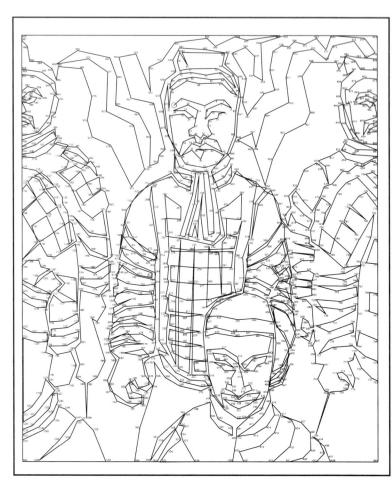

34. Terracotta Army, Shaanxi, China

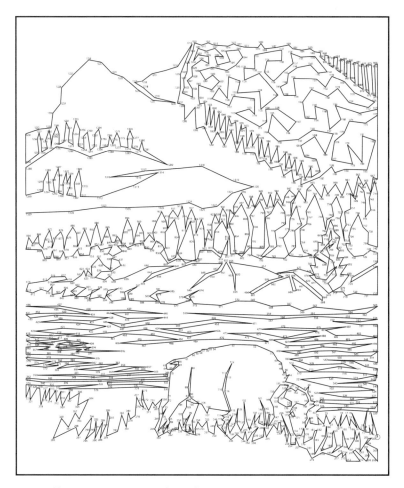

35. Yellowstone National Park, Wyoming, USA

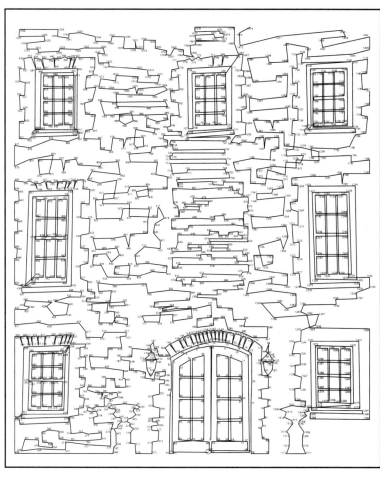

36. Savannah, Georgia, USA

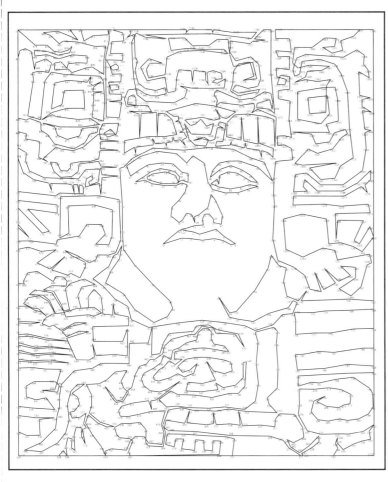

37. Mayan Ruins, Yucatán, Mexico

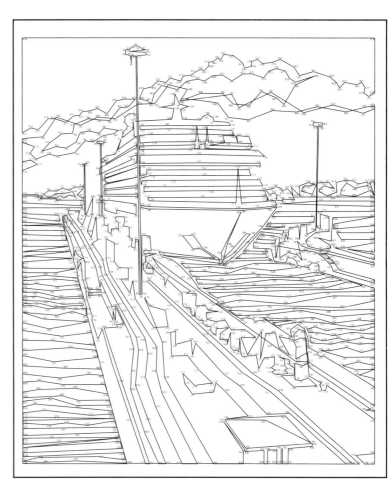

38. Panama Canal, Panama

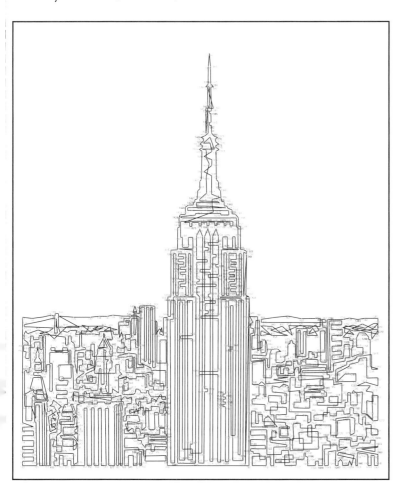

39. The Empire State Building, New York, USA

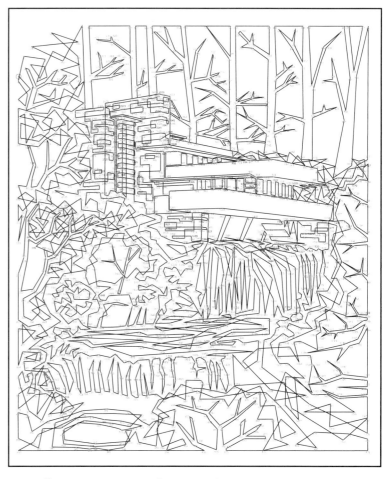

40. Fallingwater, Pennsylvania, USA

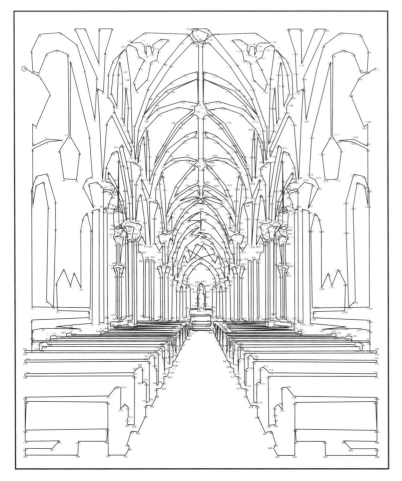

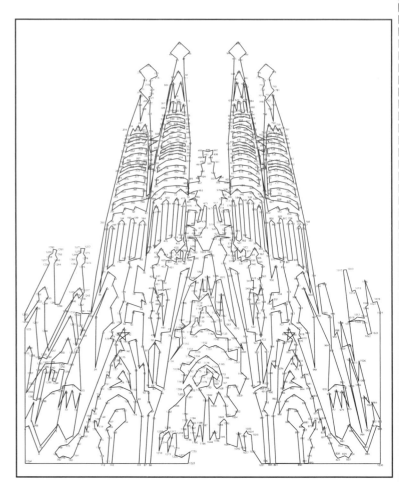

41. Church Basilica, Indiana, USA

42. Sagrada Família, Barcelona, Spain

First edition for North America published in 2015 by Barron's Educational Series, Inc.

© Copyright 2015 Welbeck Publishing Group.

No part of this publication may be reproduced or distributed in any form or by any means without the written permission of the copyright owner.

All inquiries should be addressed to:

Sourcebooks,
1935 Brookdale Road, Suite 139,
Naperville, IL 60563

www.sourcebooks.com

ISBN: 978-1-4380-0836-3

Manufactured by: Leo Paper Products, Heshan, China

Printed in China

10 9

All images supplied courtesy of iStock.com & Shutterstock.com
All dot-to-dot puzzles created by Patricia Moffett

With special thanks to Gabriel Bayne-Jardine and Jason Ward.